D0559908

George Rodger and the Nubas

Village of the Nubas is one of a small number of publications that have become classics of photographic literature. George Rodger's work on the Sudanese people of the region around Kordofan represents an important moment in the history of photography, and its appearance in Robert Delpire's short but influential series, *Huit*, confirmed the status it had earned in the illustrated press of the era.

Though published in book form in France in 1955, the history of *Village of the Nubas* can be traced back to 1945 (this volume, which appears 50 years after the pictures were taken, is the first English version of the book). George Rodger, then a *Life* photographer, had been criss-crossing the world since 1940 to record the war in all its details. Moving from Africa to the Far East, then back to Europe, he covered the Normandy landings and the liberation of Paris, Brussels, then Holland. He crossed the Rhine in April 1945, and photographed Churchill telling the troops, 'You are now entering the dire sink of iniquity.' Not quite believing the rhetoric, he drove on into Germany until he came to a place called Bergen-Belsen. Although accustomed to the gruesome inhumanity of war, Rodger was shocked as much by his own response to the scene as by what he saw. Finding himself dispassionately composing the images of piles of corpses on the screen of his Rolleiflex, he told himself,

'Never again.' After photographing the German surrender in May 1945, he became obsessed with the idea of a return to Africa, where he had glimpsed the possibilities of another way of living, 'I just had to get rid of the filth of war, the screams of the wounded, the groans of the dying. I sought some spot in the world that was clean and untrammelled – tribal Africa.'

Like many writers, artists and photographers of the immediate post-war era, Rodger felt it was time to create a world in which universal, humanist values would ensure that such inhumanity could never recur. It was in this spirit that a group of like-minded photographers – George Rodger, Robert Capa, Henri Cartier-Bresson, David Seymour ('Chim') – formed the Magnum agency in 1947. Capa's vision of a co-operative agency, which would protect and promote the rights of its members and nurture the best in humanist photojournalism, appealed to Rodger, but it also gave him the opportunity and much needed resources to pursue his African project.

By early 1948, Rodger was ready with his wife Cicely to begin his epic journey across Africa, in search of a healing innocence. And, while his quest for a humanity untarnished by 'civilization' may seem a romantic one, a latterday search for the redeeming qualities of the 'noble savage', Rodger was perceptive about the historical moorings of his project. 'I could see that colonialism was finished,' he said, 'and I wanted to photograph what was left of the old Africa, before it became ruled more by the

ballpoint than by the spear.'

Rodger was conscious that the fragile relationship of man with nature, which took such intriguing forms in the remoter regions of the continent, was balanced on the cusp of change. He wanted to record as much of this richly textured and 'primitive' life as possible before it slipped away for ever. While colonialism used Africa as a treasure trove of raw materials, the interior was largely left to its own devices, and many pre-literate native societies remained relatively untouched. As the grip of the empires loosened, this was bound to change. Rodger could not have predicted the outcome of this process fifty years later, but his photographs and writings stand as intimate and revealing insights into the state of Africa just before the great 'modernizing' changes of the post-war era began to exact their toll.

The beginning of the trip coincided with the election of Dr Malan's South African Nationalist Party in early 1948, an event which led directly to apartheid. This was not an auspicious start, and after making photographs of the elections the Rodgers were relieved to be able to get on with their travels. They took in Big Game in the Kruger National Park, the wedding of the Kabaka of Buganda, British government projects such as the ill-starred Ground Nut Scheme in Tanganyika (now Tanzania), and some of the worst aspects of colonial exploitation, such as the Williamson Diamond Mine in Shinyanga. But the high spots of the journey were

Rodger's encounters with aboriginal peoples: the Xhosa and Amangwane in the south; the Bari, Wakonjo and Bachimbiri in Uganda, and finally the Dinkas and Nubas of Sudan.

During this extended journey Rodger supplemented his funds with a number of assignments, selling 'stories' produced along the way to magazines such as *National Geographic*, *Life* and *Weekly Illustrated*. He was always the complete photojournalist, with the accent equally weighted on both parts of the term. During a 75,000-mile journey from Britain through Africa and on to India and Burma from 1940 to 1942, he had invented the 'package' story, writing detailed captions and back-up texts to support the undeveloped rolls of film he was sending back to *Life*. In most cases it would be months, and sometimes years, before he saw the results of his work, so he had to carry in his mind the threads of an unfolding story to which he would regularly contribute an instalment. The same techniques served him well in Africa, backed up by meticulous notes and diaries, and a carefully typed daily journal. To read it fifty years later brings the adventure to life with a vividness which is striking, for it records in George's incisive tones the rigours as well as the pleasures of this trip: mechanical failures, sickness, penury, the endless waits at borders for paperwork to be processed.

In some ways Rodger considered himself more of a writer than a photographer; the camera present as a

means of backing-up the written word. Perhaps this made him a better photographer, for it meant that he always saw his role as making pictures which formed part of a story. Never bothered with his reputation as an artist, he was free to make pictures which were part of a greater whole, to construct a narrative or essay which could make it possible for readers to understand the complexity of another way of life. That is why it is essential to read Rodger's carefully honed text about the Nubas alongside his pictures. Delpire's original page-layout respects the unity of Rodger's essay by interleaving plate and text sections. Although all three share a similar format, Rodger's book was the only one in the *Collection Huit* where the photographer was also the writer. Those of Doisneau and Cartier-Bresson carry literary texts alongside their pictures.

The Nuba photographs were made between 21 February and 4 March 1949, and were part of virtually the last project Rodger carried out during the African journey. By this time Cicely was quite pregnant, and he was anxious for them to return to their home in Cyprus for the birth. They had been in Sudan since the beginning of the year and Rodger had been cabled, in Dar es Salaam from the Magnum office in Paris, that it might be worth his while to try and get into the Kordofan province of southern Sudan to photograph the Nuba people. Access was difficult for reasons of geography as well as bureaucracy, and on one occasion (21 February 1949)

Rodger notes in his journal, 'When there is total Sudanization in this country then I doubt if anything will get done! It is bad enough as it is.'

It is evident that Rodger was fascinated by the Nuba people, at once so remote and yet remarkably friendly. He worked in two formats, making pictures with both a Rolleiflex and a Leica, for 'they were the standard equipment of *Life* photographers, the Rollei because they liked a large format, crisp picture for the lead photo and then the Leica so you could do the fill-in stuff.' Although most of the pictures were made on black and white film, Rodger also produced some colour transparencies. Looking at his contact sheets one is immediately struck by the economy of means Rodger brought to this situation. His 6x6cm Rolleiflex images tend to focus on the more static subjects, single individuals or small groups of figures, and landscapes; while the 35mm Leica pictures capture movement and details. Each 'scene' rarely encompasses more than 3 frames, and the whole 'story' is completed in about 30 rolls of film. Hardly a frame is wasted. This economy, learned the hard way during Rodger's wartime travels, reminds us that constraint is often the spur to creativity. All of his pictures have a spare and elegant composition, as if the shutter was only clicked when all of their elements had fallen into place in the viewfinder.

For George Rodger, return to Europe proved as tragic as his experiences before the great African expedition. In

July 1949 Cicely's baby was stillborn, and she died a few days later. When *Le Village des Noubas* was published in 1955, it carried the dedication, 'A la mémoire de ma femme Cicely, pour qui ce voyage fut le dernier.'

Each great photographer seems to produce one iconic image which distils their oeuvre. In Rodger's case it is his masterful portrait of the Korongo Nuba wrestling champion, carried shoulder-high by a defeated foe. In this one photograph, all Rodger's respect for the Nubas and admiration for their way of life is concentrated. As in so many of his pictures the camera looks up, almost as a mark of deference to the nobility of these people. Yet he would never return to see them again, despite many attempts, always defeated by war, bureaucracy, transport or geography. He felt saddened that his words and pictures, published in magazine articles throughout the world, brought the Nubas to the attention not merely of the outside world, but their own government. The newly independent Islamic state pressured the Nubas into changing their way of life, obliging them to cover their bodies and outlawing their fighting contests.

Using his journal as source material, Rodger wrote the story in the spring and summer of 1949 and sent it for distribution through Magnum in Paris and New York. It first appeared in *Weekly Illustrated* magazine in October 1949, where it ran over eight pages. Later, in February 1951, *National Geographic* published a longer version running over thirty pages. The wrestler picture

appeared there (as it would do in *Life*) and caught the eye of the German photographer and film-maker Leni Riefenstahl. She wrote to Rodger, asking him to divulge the location of the tribe, and offering him a thousand dollars for an introduction to the wrestler. He wrote back, 'Knowing your background and mine I don't really think we have much to communicate.' However, she was persistent, and photographed the Nubas twice, in 1962 and 1975. Her books (published in 1973 and 1976) acknowledge his influence. Yet, although their subject-matter coincides, their perspectives are diametrically opposed. Riefenstahl treated the Nubas as an exotic species, paying them to undress and to stage illegal fighting contests. Rodger, by contrast, was always primarily concerned with their fundamental humanity. His friend and colleague Tom Hopkinson, editor of the *Picture Post*, most aptly summed up his approach, and in the process provided a clue to the recessive nature of his public reputation. He wrote, 'The photographer never comes between subject and viewer: it is, in a sense, his absence which allows the scene to happen.' In Rodger's best work, the photographer is a witness, there on behalf of the reader, and as such, his pictures are always infused with a profound humanism.

Peter Hamilton, 1999

Village of the Nubas

VILLAGE
OF
THE
NUBAS

Φ

Photographs and text
by George Rodger

In memory of my wife Cicely
for whom this trip was the last.

From Nuba slaves to Nubas

The Face of Africa is undergoing a change. Progress and education are reaching far into its darkest regions. This metamorphosis is felt all the way from Cairo to the Rand, from Lagos to Mombasa and soon the Africa of Brazza and Livingstone will be a thing of the past.

The age of the great warrior tribes – the Zulus and the Masai – is over and the days of the witch-doctor, who tries to hold on to his power at all cost, are numbered. Government by fear and witchcraft is gradually being replaced by an administration whose characteristic tools are paper and ink; the mass-produced ballpoint pen is carried in preference to javelins.

In spite of the post-war development of airlines and a network of new roads, opening up remote regions to travellers, parts of Africa remain inaccessible. And, it is in these regions, around which nature has built a protective wall against the incursion of the West, that one can still find the real Africa, untouched by white influences, preserving the customs and traditions of the ancient tribes.

Such is Kordofan: a remote and primitive region to which access remains very difficult.

In the heart of the Sudan, and to the west of the White Nile, there is a strange, unreal land which the hand of time has hardly touched in passing. It is known as the 'Jebel Country' and covers about thirty thousand square miles of the Sudanese province of Kordofan.

High mountains, formed of solid rock which has been

scraped bare by erosion, rise as high as four thousand feet above the surrounding plain. They are weathered by the wind and blown sand into fantastic shapes of rugged outline. Emaciated trees and sandbanks heighten the impression of unreality. It is among these grotesque jebels that the people of the land have built their villages. Today, 300,000 Nuba inhabitants form a human enclave of aboriginal Negro stock surrounded by groups of newcomers of Arab, Hamitic and Nilotic origin.

It is likely that the Nubas were the earliest inhabitants of this area, although we have no knowledge of their real origins and racial genesis. They only enter written history with the coming to power of a certain Muhammad Ahmed – the Chosen One – the son of a canal builder from Dongola who proclaimed himself to be the long-awaited Mahdi. Despite being pagans, the inhabitants of the villages rallied under his Islamic banner and with them he waged a rapid campaign across the whole country, liberating its peoples from the Egyptian tyranny. In 1883 he wiped out an army of 10,000 Egyptians led by the English general, William Hicks, and this victory was the first step on the road to the separation of Sudan from Egypt. General Gordon was killed by the Mahdi's men at the fall of Khartoum. Then, in 1898, at the epic Battle of Omdurman, Lord Kitchener reconquered the country, which was turned into a condominium under the joint control of the British and the Egyptians.

All we know about the Nubas before this relatively recent history is that in the course of the centuries, they were a prolific source for the slave trade in the Middle East. Even the ancient Greek and Roman chronicles refer to Nuba slaves. During the Mahdist regime this territory was a rich hunting ground for marauding Arabs and a prolific source of supply for the slave traders who came from the north by camel-caravan and carried back with them the young people from the villages to be auctioned on the slave-blocks in the coastal towns of Arabia, in Aleppo and Baghdad. It was these slave-raiding Arabs who drove the Nuba tribesmen to take refuge in the jebels.

They lived there throughout the rule of the Mahdi, a little less vulnerable to attack by raiders but completely isolated from the world which reached out below them; isolated also from their fellow tribesmen who had fled to other groups of jebels.

Gradually, throughout three centuries of fear and oppression, of living in hiding and segregation from their fellow men, the Nuba tribe became decentralised and the people inhabiting each individual group of jebels developed their own tribal characteristics. Each group adopted a dialect of its own and also customs that differed from those of their neighbours. Today, there are fifty different groups of Nubas, each with its own language and each group conscious of its ethnic individuality.

Though there has been peace in the jebels since the turn of the century when Kitchener, having defeated the last of the Mahdi at Omdurman, abolished the slave trade, the Nubas are still as firmly embedded in the jebels as the very rocks among which they live. They still prefer their rugged fastnesses to the flatlands where now nomadic tribes of Baqqara Arabs graze their herds. But, in their seclusion, progress of any kind has passed them by. They are as primitive now as they were three centuries ago and their continuing existence forms a rare link with the Africa of time passed.

Village of the Nubas

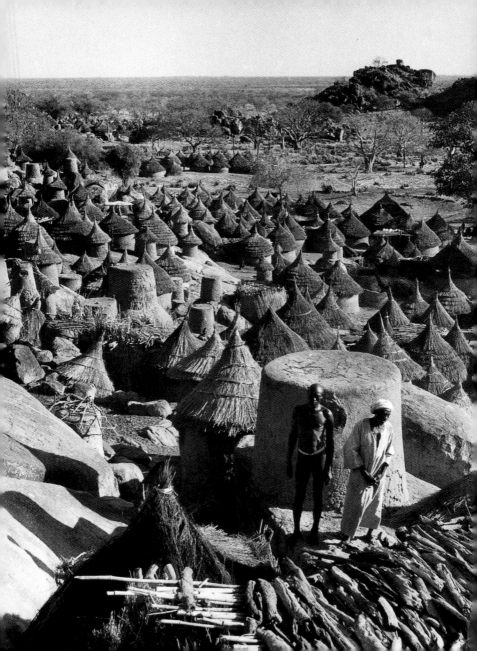

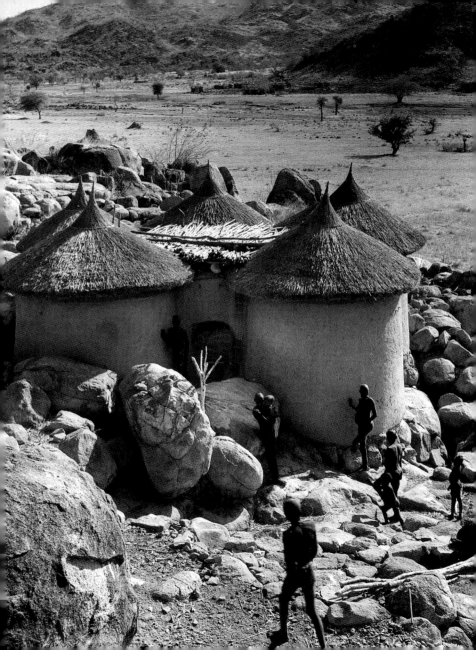

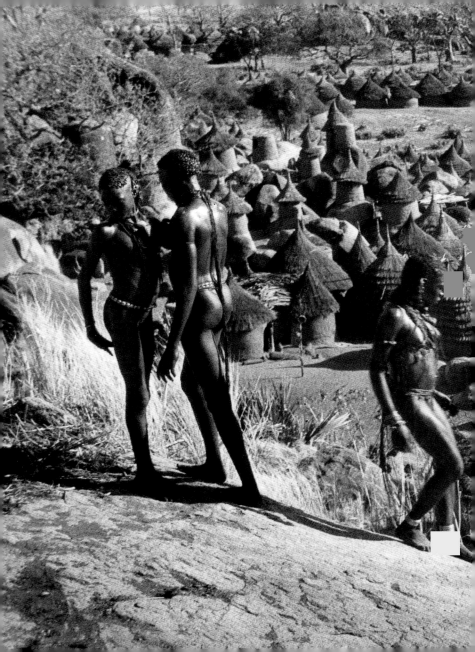

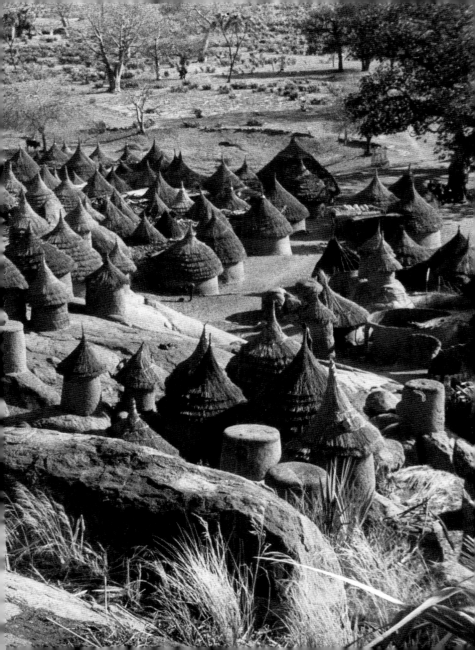

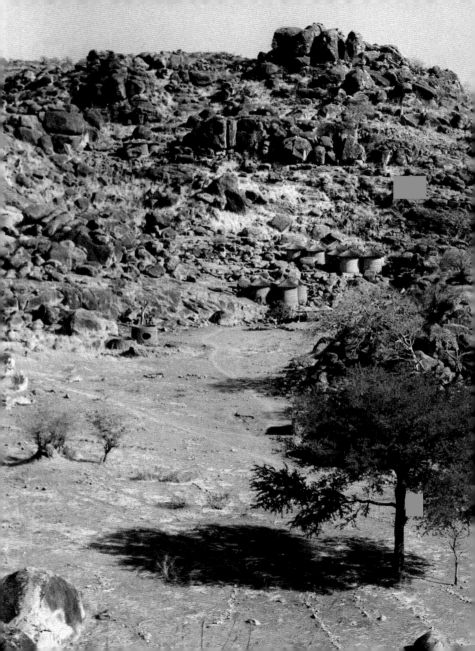

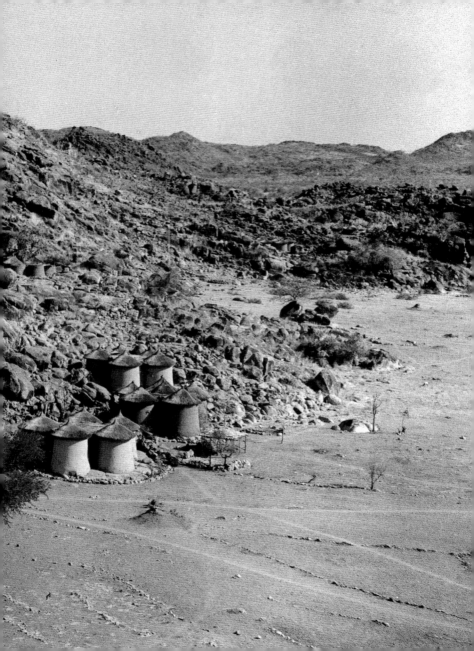

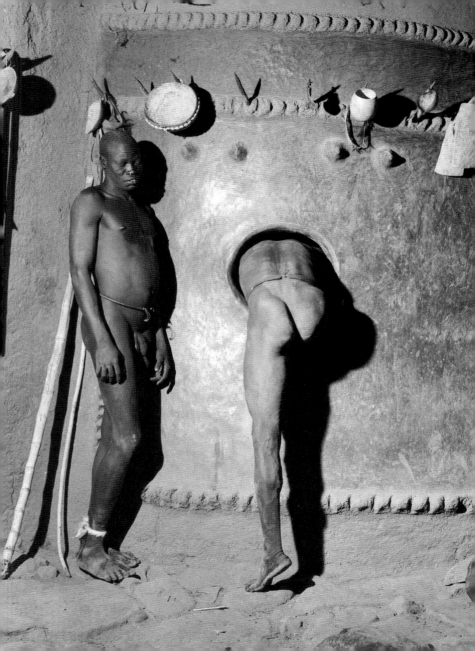

A road with no water
but with elephants

No visitor is allowed to enter the Province of Kordofan without the written permission of the Sudanese government in Khartoum. This is a 'closed region' – as much in the physical sense as in the diplomatic sense. Therefore, when my wife and I arrived at the southern frontier of the Sudan from the Congo, after having already trekked through twenty thousand miles of equatorial Africa, and wished to see the fabulous land of the Nubas and to photograph the savage tribal sports of its people, we had first to apply to the Sudanese government for the necessary permits. These were readily issued but there remained the physical barrier of the land which would prove much more difficult to conquer.

Much time was spent checking, by signal, on the condition of the routes we would have to travel, from the south and across the swampy areas of the Sudd. It is only possible to reach Kordofan by road during a very few weeks in the year between the floods and the rains as the region is protected from intrusions by vast impenetrable swamp lands.

There were to be two possible routes: one passed through the west across the Province of Bahr el Ghazal; while the other filed directly north over the Province of the Nile. Each meant driving a distance of over 7,500 miles.

The Governor of Bahr el Ghazal signalled that the waters of the Bahr el Arab and the Lol rivers on the western route were still running high and it would be five

or six weeks before it would be possible for us to ford them with our safari vehicles.

We chose the alternative, the 'River Route', which followed the course of the Nile to Bor and, from thence, to Malakal which, although still in Upper Nile province, might be considered one of the southern approaches to Kordofan. The District Commissioner of Bor signalled to say the Nile had receded and the route would be passable in about two weeks. But he said we would have to lose no time as the rains, which were due at any moment, would close it again for the remainder of the year. He ended his message with these words of advice, 'Mind the elephants.'

We started from Yei on the frontier, between Sudan and the Congo, with two vehicles, camping equipment and enough supplies, water, and petrol to keep us going, if necessary, for several weeks in that wild jungle which we would have to cross.

We headed first for Juba, around a hundred miles away, which was the closest point where it was possible to cross the Nile from the west bank to the east. Then, crossing the Nile at Juba, we followed the river down through thick bush country inhabited by Dinkas and drove along the river, alternately through thick jungle and tall forests of extraordinary beauty.

The surface of the track was soft from the Nile floods

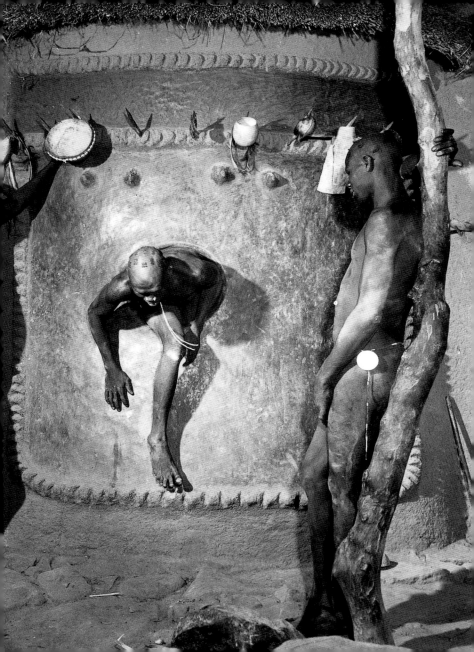

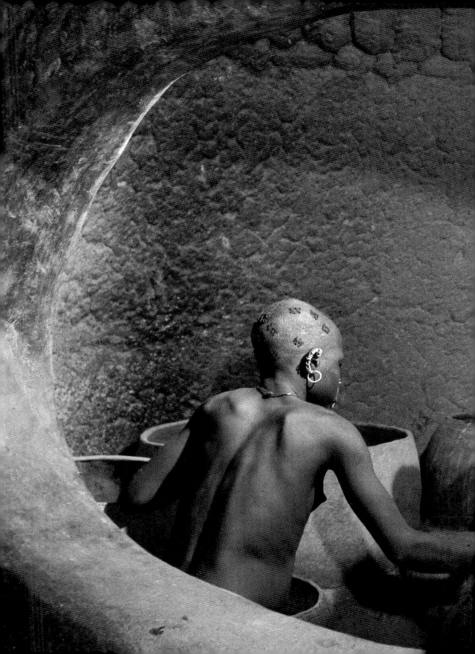

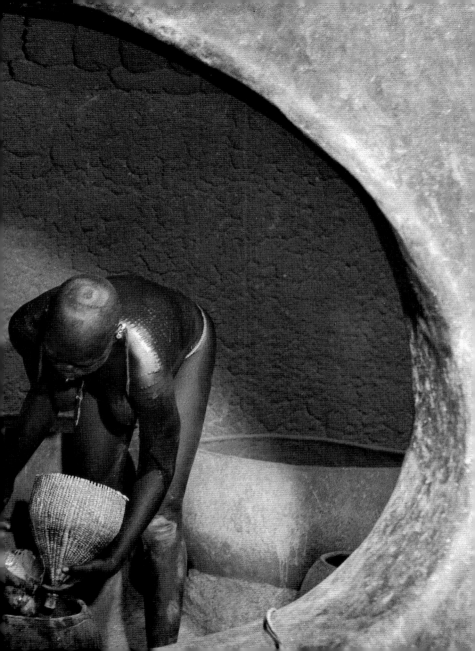

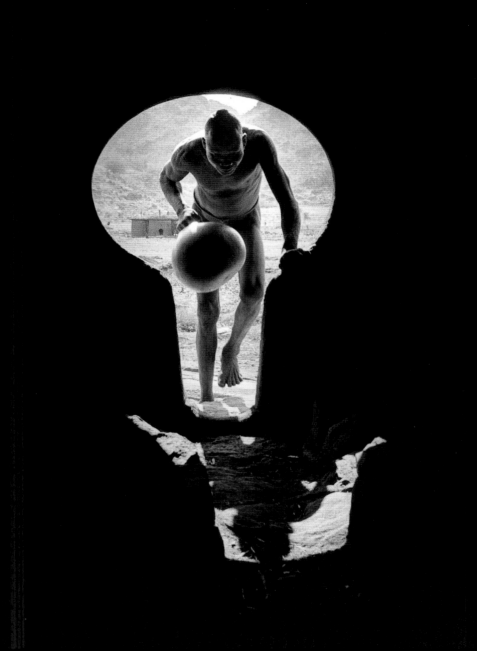

which had recently receded, the mud only just beginning to dry out. In this mud, the deep imprints elephants had made were plainly visible. In their daily pilgrimage to water they crossed the track night and day, leaving in it footprints that were as much as two feet deep and very difficult to drive over. We were reminded of the district commissioner's warning.

It was just as the sun was going down that we encountered our first elephants. They were not crossing our path but rather moving alongside it, heading towards us, with the huge grey mass of a male out in front. We were, as it happened, in a forest, on an extremely narrow track and because of the density of the wilderness, it was impossible to move aside completely, nor did we now have sufficient room to manoeuvre a turn. The elephants approached us, slowly and relentlessly. I knew that these animals had an irritable temper, and that any attempt to hold one's ground against this monarch of the forest would be very dangerous. At all cost we had to give way. By forcing the Jeep into the dense undergrowth, we gave them as much space as we could. The native driver brought the second vehicle behind ours. Then, after opening the door on the forest side, in anticipation of having to make a necessary and hasty retreat, we waited in silence.

They had only to swing their trunks to touch us as they passed. But they advanced in single file, thirty of them in all, their heads nodding as if they were half

asleep, their stomachs grumbling. There were old ones and young ones, and babies not four feet high. Not one of them lost their dignity to give us so much as a glance.

After five hundred miles of 'river road' and bush track we reached Malakal, and crossing the Nile again to the west bank, we came to within eighty miles of the Kordofan boundary. The track was appalling. It crossed black cotton-soil which was rough, baked hard by the sun and cracked like the veins of a hot-house melon. The sandy stretches were smoother and there the dom palms grew, the grotesque baobab trees, heglig and talh thorns. In the dust were the tracks of many animals – large buck, elephant, giraffe and lion.

We camped that night in Kordofan, on the southern boundary of the Kordofan province. It was a very hot night and still, and a moon, two-thirds full, gave sufficient light so we could pitch camp without the aid of lanterns. An Arab, watching over his herd in the pastures, brought us water which was saline and muddy but quite drinkable and we had our supper under the stars and slept with the distant cries of hyena and the rumbling of lion around us.

On the following day we reached the 'Jebel Country' and the road twisted between mountains curiously constructed by nature of piled boulders. Stunted poison trees with their wax-like pinkish flowers broke through

the stony ground and, in the valleys, the green, shady haraz trees bore their curled yellow seed-pods, which the Arabs feed to their camels.

At last, the villages of the Nubas came into view. They hung so high and were so much a part of the terrain that it seemed the little pot-bellied huts, with their thatched roofs, had been taken by the handful and hurled against the mountainside to settle in the crevices, between the rocks, where the wind and the weather and the passage of time had merged them into one with the jebels themselves. Some had lodged in sheer-sided ravines, others clung precariously to the bare rock and some were perched jauntily on the tops of bald boulders like the fanciful creations of some whimsical milliner. Children ran up and down steep rocky paths as agile as the jebel goats and, at the foot of the jebels, on the flat land, the girls of the village watered their tobacco crops from large yellow gourds, which they carried on their heads from the wells.

Of tremendous stature and physique, bullet-headed and beetle-browed, the tribesmen appear fierce and war-like. But they are peaceful now and prefer athletic diversion to fighting with their neighbours, though, in more civilized eyes, this might seem lethal enough. Each tribal group specializes in a different 'sport' – spear throwing, wrestling, stick fighting or, the most lethal of

all, bracelet fighting – and, especially with their sticks and bracelets, they fight to within a very small margin of death. But, in spite of these blood-thirsty recreations, they are a good-natured, easy-going and happy people. Unencumbered by worldly possessions – for they have none except perhaps a cooking pot and spear; unworried by money – for they have no need of it; unembarrassed by their lack of clothing – for they have never worn any, they are indeed primitive but their lot is more enviable than that of their semi-educated, more bewildered black brethren in other parts of tropical Africa.

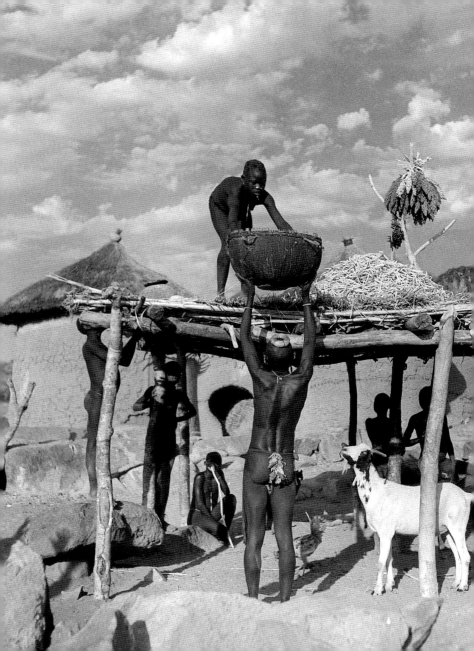

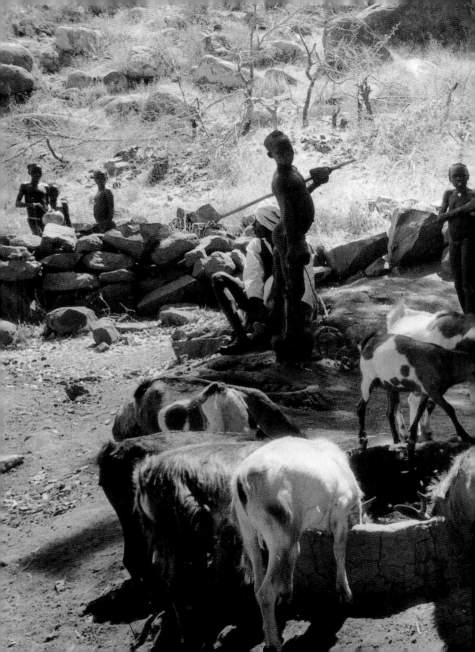

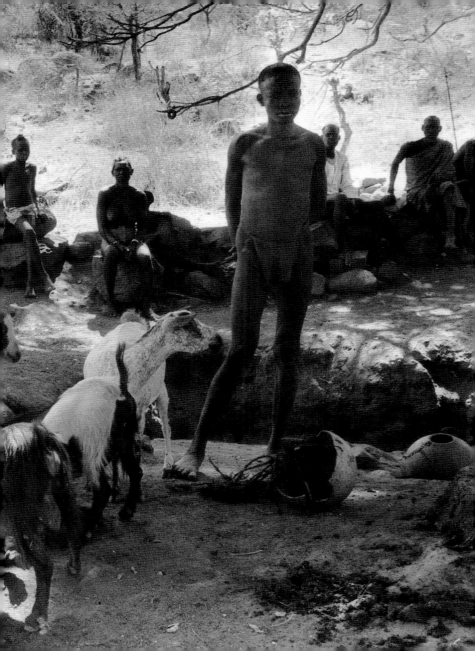

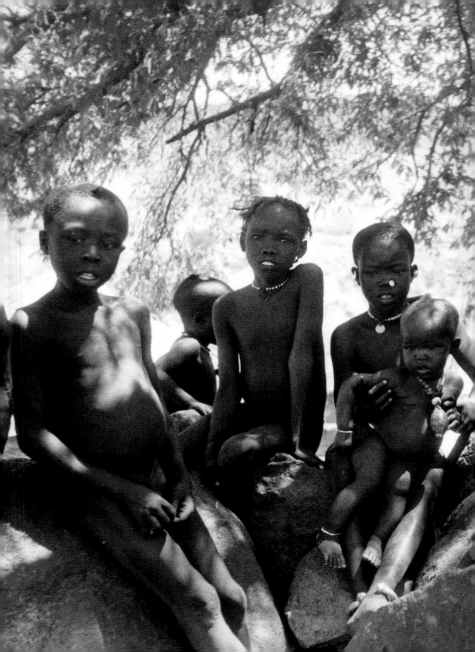

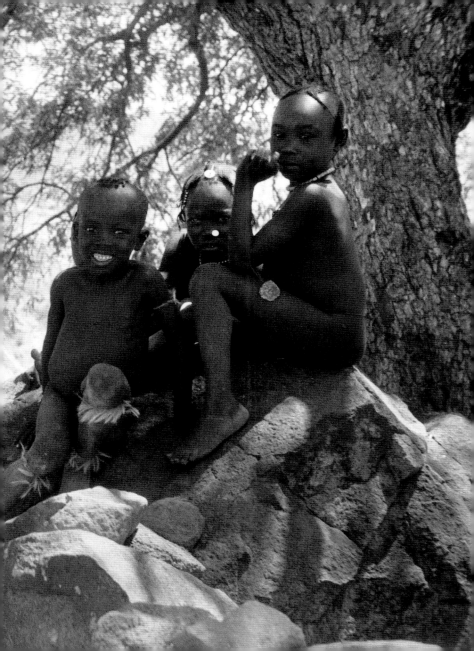

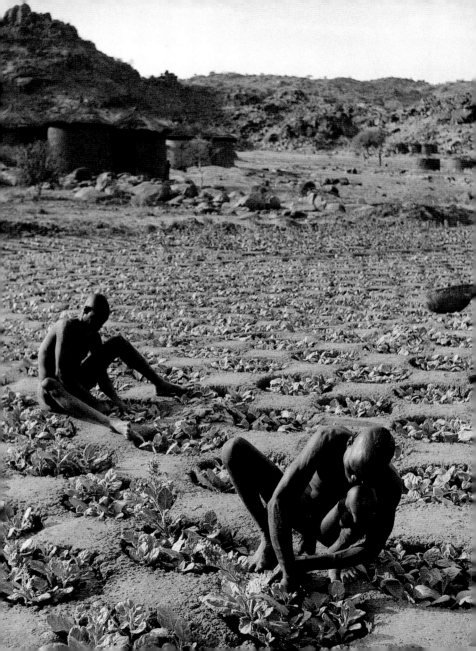

Prelude to a spectacle

We were camped in the village of Reika when the Mek of one Nuba group, the Masakin Qsar, came to pay us a visit. He was an Arab in flowing white robes and he wore a turban in accordance with the ways of his kind. In view of the upheavals of the past and the slave trade to which I have made mention, it was surprising that the Nuba should have agreed to be led by a Muslim. We subsequently discovered that this custom was widespread throughout the land of the jebels. Though the position of under-chief was often held by a Nuba, the chief was usually an Arab.

The Mek of Masakin Qsar was dignified and polite. He bowed, shook our hands and bade us welcome to his homeland. While he was speaking, I caught sight of a sheep being dragged reluctantly behind the encampment and tied to a post. It was the traditional gift of welcome and the sheep, as if aware of this custom, was bleating pitifully as it waited for the moment when it would be sacrificed.

In Kordofan it is regarded as impolite to begin a conversation with reference to the principal reason for one's visit, likewise to display any curiosity or to be over-interested in the affairs of one's visitors. So the Mek asked us first how our journey had been, if the road had been good, and the days of travelling short. He made no inquiry whatsoever as to where we had come from or where we were going. We supplied answers that were non-committal and asked in our turn whether the

harvest had been a good one and if there had been enough rain. 'By the good grace of Allah,' he told us, 'everything was fine.' But he would have given us exactly the same answer during a period of extreme drought or widespread famine. It is considered indelicate to express one's dissatisfaction to a stranger.

At this moment our kitchen boy brought the tea that I had ordered and we spent ten minutes sipping the hot sweet liquid, making approving noises, but not actually uttering a single word.

Having enjoyed his tea and finding that we were not, after all, such boors in the matter of etiquette as he had previously thought, the Mek provided us with an opening by asking if the neighbourhood was to our liking and whether the people of Masakin Qsar had treated us well. Keen not to display too much enthusiasm, which would likewise have been considered crass, I answered that our welcome had been just as we had expected and that no one had caused us any problems.

As for the neighbourhood, we had found it very interesting – in fact interesting enough for us to spend a little time, precious though that always was, taking a few photographs of the villages and the people. I then asked him if he thought there was anything which was of particular interest. In this way I had held my own and was repaying him in kind. He answered that a *sibr* was soon to be held in the neighbouring jebels of Korongo and that, if this event was of interest to us, we could join

him as spectators. A *sibr* (the word is Arabic), we came to understand, is a gathering of the people in commemoration of a tribal event and, among the Nubas, it almost always includes a display of their athletic prowess. The Korongos, probably on account of their terrific physique, are the finest wrestlers of all the Nuba tribes. This invitation was an opportunity for us to witness the tribal 'sports' we had come so far to see. Without further ado, we accepted his offer knowing full well that he had only decided to extend the invitation once he was assured of our genuine interest and, knowing also that he would arrange for a ceremony of the utmost pomp. For such was the nature of traditional hospitality among the Nubas.

The *sibr* began mid-morning, under the fierce heat of a sun already high, and the scene was set beneath the heglig trees below the village of Buram.

When we arrived the wrestlers were seated in the shade of thorn trees talking quietly among themselves. They were men of tremendous physique, each one standing well over six feet in height and broad in proportion. They were completely naked and had rubbed their bodies with white wood-ash so they could grip more easily while wrestling. Their heads were shaved except for a few small, decorative tufts of hair.

After a while, a strange procession wound its way

down from the village in the jebels. It was preceded by a naked tribesman beating a large drum. Behind him came several women each with a wide, shallow bowl balanced on her head. In the bowls there were plumed belts made from the coats of the colobus monkey, ostrich feathers and ornamental armbands to be worn by the fighting men.

Behind these women came more wrestlers, white with wood-ash. The ragtag of the village followed after, dancing, drumming, singing and waving their spears. All of them, men, women, and children, were naked, although some of them had devised special adornments of striking originality for the occasion. One girl was decorated with bands made from the metal tops of beer bottles which she wore on strings around her neck and waist. An immense and muscular gentleman proudly bore a whole sun-dried heron with widespread wings on his back. Another had a bank of brass bells strapped around his stomach. Many wore ostrich feathers and some, already covered in wood-ash, beautified themselves still further by tracing designs in it with soot. The older women had rubbed themselves in sim-sim oil so they were sleek and shining.

At the tail of the procession fifty young girls filed into view. They walked one after another, carrying gourds of marissa, the native beer made from the juice of the dom palm tree, balanced on their heads. Their posture was superb and they even danced to the beat of the drums

without spilling a drop of the potent brew they carried.

Once everyone was gathered, without noticeable origin an order was established and in a few moments a barbarous orchestra was formed. The drummers assembled in one group and the trumpeters beside them using the horns of a variety of animals as instuments. The horn of the koudou gave a profound bass sound while that of the kongoni was more moderate and the fine horns of the gazelle emitted a high piercing pitch. As the drummer beat out an increasingly frenetic rhythm, the procession approached and the wrestlers detached themselves and advanced. Strutting in a crouched position they flexed their muscles. With each step they grunted in unison and the young girls ran beside them making a high-pitched trilling sound by passing their tongues rapidly between their lips.

Traditional wrestling

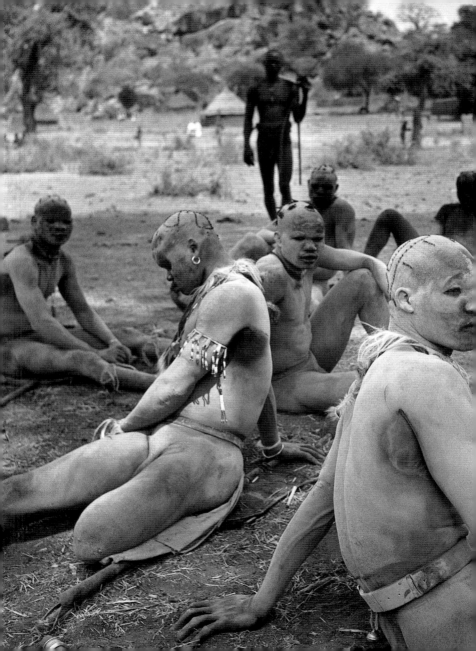

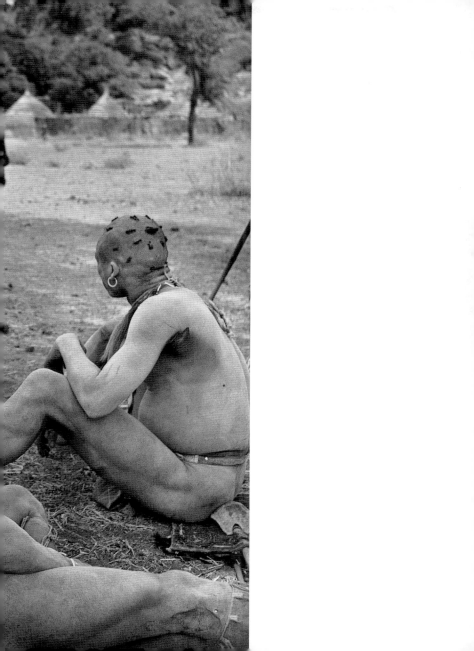

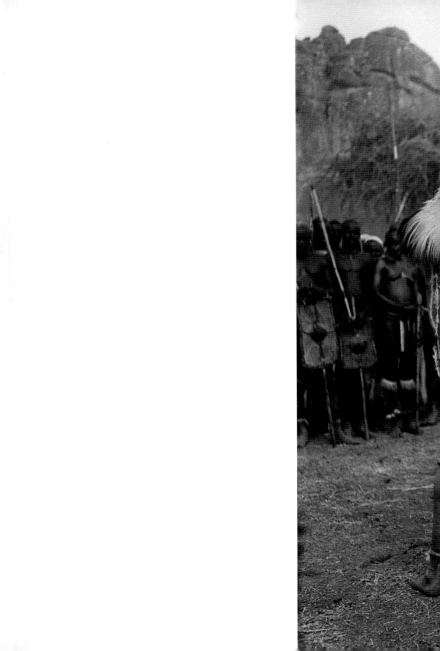

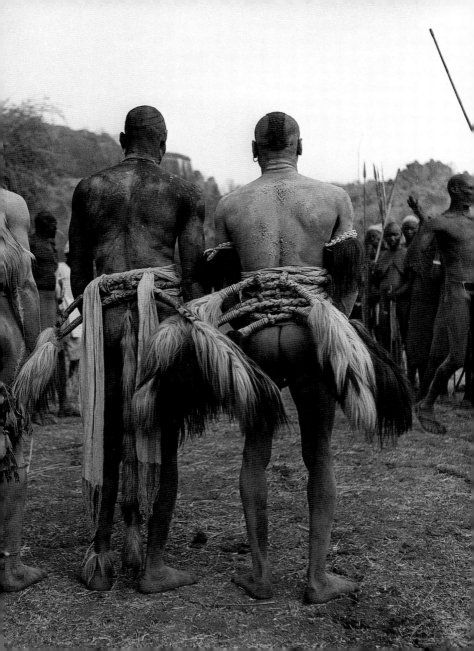

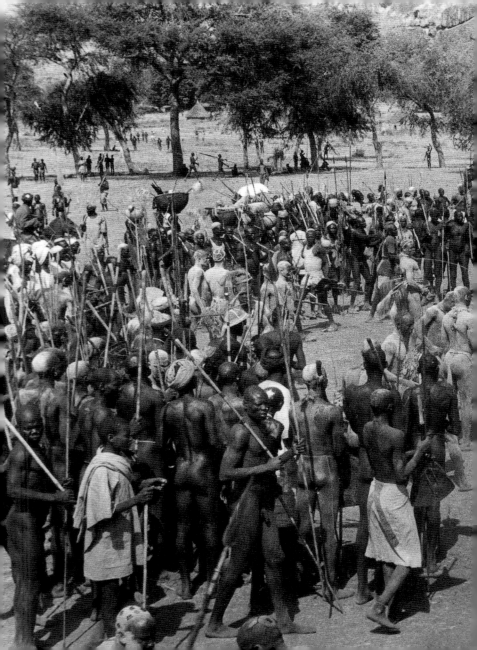

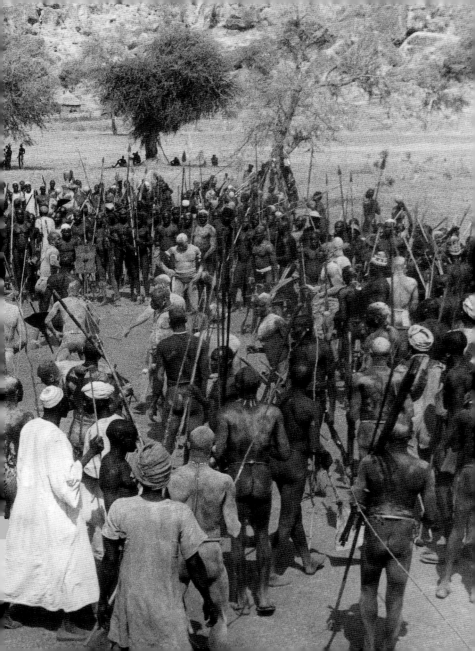

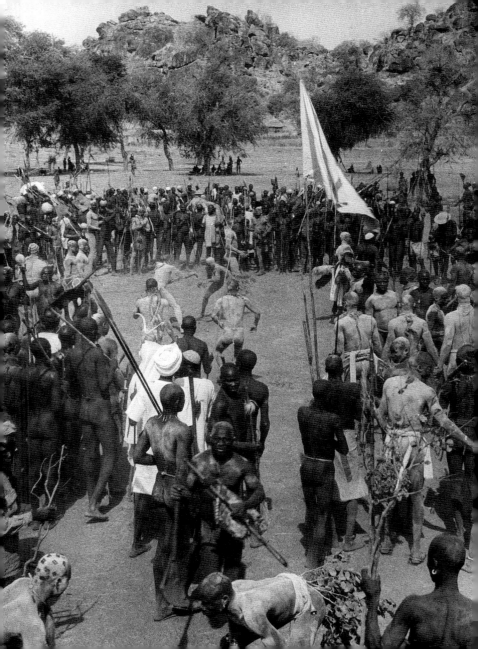

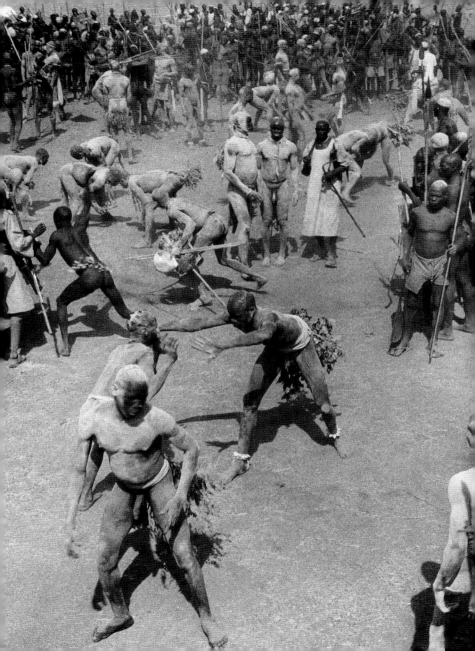

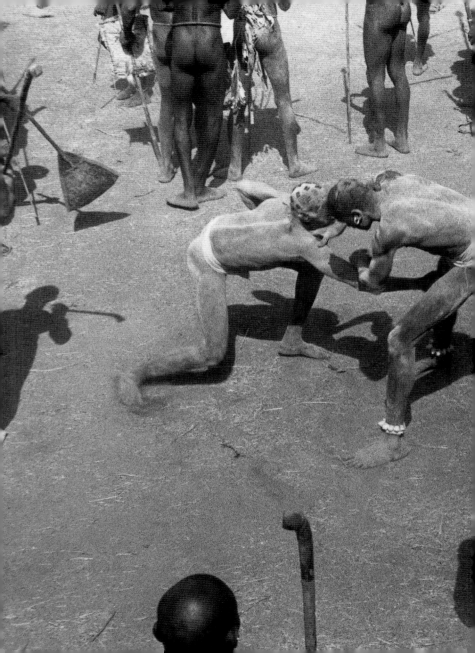

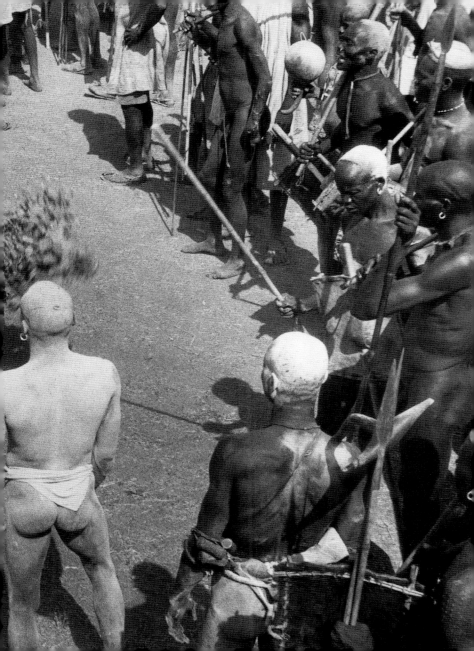

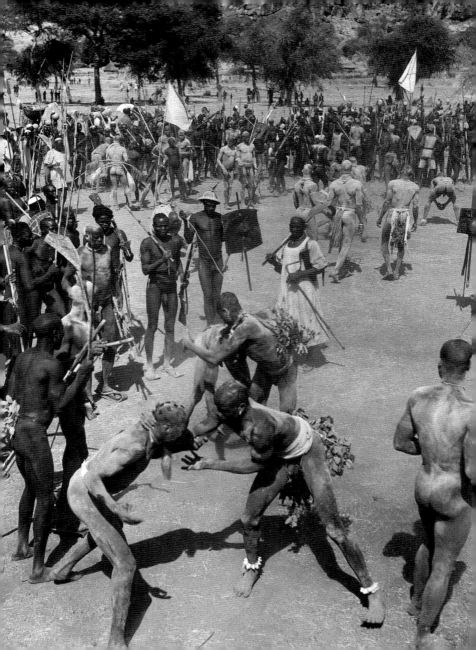

Where brutality does not exclude emotion

Without very much order, the wrestling bouts began. The onlookers formed a rough circle around the competitors who faced each other in pairs. There were sometimes half a dozen bouts in progress at the same time. First they crouched and snarled at each other. This went on for several minutes until, suddenly, without warning, they grappled. The crowd roared encouragement, waved their spears and pressed closer for a better viewpoint until fighters and spectators formed one inseparable mêlée. The drummer beat harder to an accelerated rhythm. A medicine man flagellated the ground with a leather flail to keep away the evil spirits. A dull roar from a thousand throats announced that someone had been thrown.

Eventually, the winner was hoisted onto the shoulders of a husky giant to be carried through the throng while the women trilled in a high key before him.

It was wild and primitive but a very stirring scene.

Then, fresh fighters arrived. The women sprinkled them with the white ash which they shook from long-necked gourds. The girls passed the beer around and another bout began. The circle was closed once more and the wrestlers again began grunting, wrestling and putting their enormous strength to the test. The wrestling bouts went on through the whole of a hot afternoon and the pace accelerated as the sun set and the intake of beer

increased. But although excitement was at a high pitch, we saw no signs of bad temper between the wrestlers. They fought savagely but without any foul play. And, when someone was brought to the ground and the winner was declared by the approving roars of the crowd, the fury of the battle immediately calmed down. Both winner and loser laughed together, and enjoyed the celebrations with as much pleasure as any of the spectators.

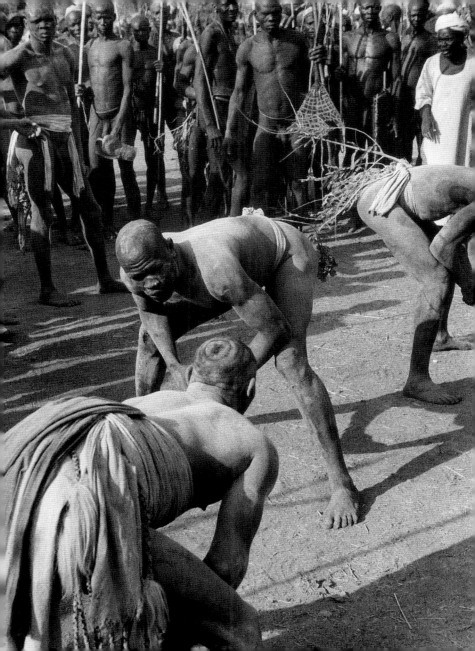

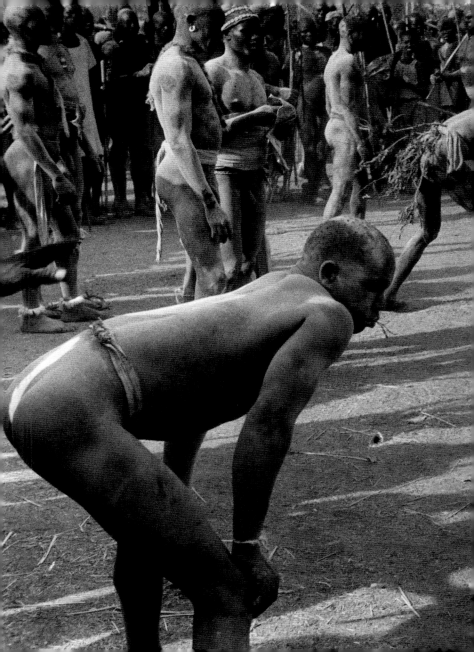

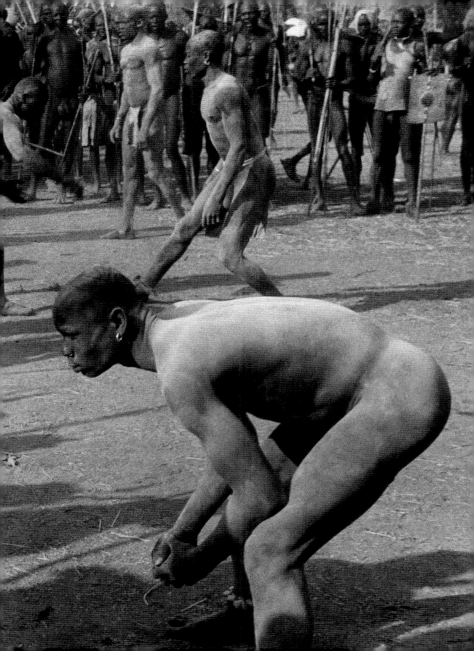

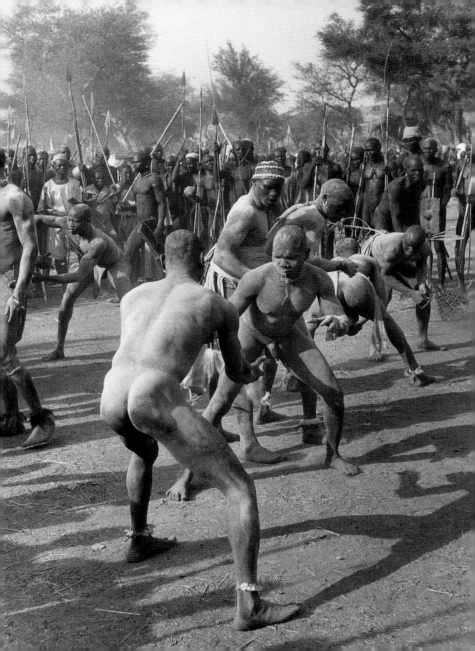

Wherein the sacred sword
must be earned

We left them in the late evening to return to our camp. But we spent a sleepless night. We were attacked by safari ants – a vicious black type, an inch long with a bite like a red hot needle – and we found no peace that night in Reika. These ants came into the camp in their millions and there was nothing else for it but to evacuate and spend the rest of the night huddled in the Jeep, trying to get some sleep as best we could. By the morning, the ants had gone on their way. This is the kind of nocturnal visitation which is bound to happen in Africa.

Clearly, our appreciation of the wrestling bouts at Korongo had been broadcast far and wide from one jebel to another and, since he did not want to be outdone in hospitality by the Mek of Masakin Qsar, the Mek of Masakin Tiwal invited us to a display of the stick fighting characteristic of his tribe. He apologized for not coming to visit us in person, but he sent a runner who verbally delivered his invitation as well as his apologies.

The following day, we therefore made our way to the jebels of Masakin Tiwal. For some ten miles we followed a rocky track – in no way meant for motorised vehicles – and then, when the path petered out completely, we continued on foot. The Mek himself had come to meet us at the head of the valley. We learned that his name was Sheikh Salim Abdullah. He was accompanied by his second in command, Sheikh Ishmael Abdullah. Like the

Mek of Masakin Qsar, both of them wore clean white robes and turbans. After formal greetings, in the shade of a baobab tree we drank glasses of hot tea made sweet with spice and honey.

Revitalized by the tea break and our topics of conversation exhausted, we began the long ascent to the village, hidden in the highest reaches of the jebels. But first and foremost, the Mek insisted we see the *Topari*, the sacred sword of the Masakin Tiwal. It was kept on the highest peak of their territory. We raised our eyes towards the summit and asked ourselves how we would ever reach such a distance.

It was very hot and the path wound steeply up among boulders which threw the heat back into our faces. As we passed the Nuba houses which were hidden high up among the rocks, the people came out to shake hands with us. And, although they had rarely encountered white people, with the exception of their District Chief, they approached without a sign of timidness, smiling with outstretched hands in greeting.

They had an unusual handshake which consisted of holding each other's fingertips and clicking third fingers as one might against one's own thumb. The girls, adorned in festive regalia, had red beads on their foreheads and in their hair offset by a single string of blue or yellow beads around their waists. Their faces were paint-

ed with designs in cobalt blue. The nipples of their breasts were also coloured and their bodies were so heavily plastered with sim-sim oil that they glistened in the dazzling light. After greeting some twenty or thirty, my hands were glutinous. I found, however, that with really sticky fingers, it was much easier to make the 'click' so necessary for a really good handshake.

Before we reached the top of the jebel it grew so hot that we were glad when Sheikh Salim Abdullah announced a halt beneath a baobab tree and water was called for. It was brought from a local house in honey-coloured gourds ornamented round the brim with rows of cowrie shells and borne on the heads of six dusky Venuses. The gourds went round from mouth to mouth and we drank the honey-sweetened water. Then native beds were offered and embroidered cloths thrown over them for us to recline on. We rested for an hour in the cool shade while all the children of the village came up shyly, one by one, to click fingers with us. They were charming little creatures, friendly, healthy and clean, with none of the bombast so prevalent among native children in more civilized areas. Rested and rejuvenated, we continued on to the arena where the stick fighting was to take place.

The path twisted and turned in a tortuous manner, uphill all the way; we wore ourselves out trying to keep

up with Sheikh Salim Abdullah's cracking pace. In his dazzling white attire, he would disappear behind the rocks only to reappear a little later, one level higher. Sheikh Ishmael Abdullah, who was more corpulent, followed in the rear and doubtless rejoiced in our inability to sustain the pace adopted by his agile superior.

Several times over, we had the impression that we were getting close to the summit. We were, however, nowhere near it, our legs were turning to lead and we could scarcely catch our breath. All of a sudden a long halloo reached us from high above. We looked up and saw the Mek, who had finally come to a halt. He was standing on a rock with his white robe floating in the wind and he was holding a sword raised above his head, the sacred sword of Masakin Tiwal.

When I finally reached him I was quite embarrassed by my exhaustion, for he had exactly the same regular breathing as under the baobab tree. I admired the endurance of this elderly man.

On his outstretched palms he held the sacred *Topari*; it was rusty and the blade was corroded with age. But this long weathering had not been enough to obliterate its origins. Without a doubt it dated from the time of the crusades.

I asked him for some details about its history. But there were none. All that Sheikh Salim Abdullah could tell me was that the fathers of the fathers of the old men, and perhaps their fathers before them, had said that

when the people of Masakin Tiwal sought refuge for the first time in these jebels, they found the sword stuck in the ground at the very spot where we were now standing. On it they had built a mausoleum and had adopted the sword as the sacred symbol of their tribe.

With veneration the Sheikh set the sword down again, and as we returned down the same path I reflected on the meaning of this history. Did the crusaders penetrate this far south or was it merely that the sword had been brought to Kordofan by some Arab who had fought against them? It was a question which I had no hope of answering.

The descent was much less tiring than the climb, as one might suppose, and we soon arrived in the village where the stick fighting was to take place.

The fighters arrived heralded by men beating drums. They were dressed rather strangely. They wore head-dresses like helmets of jagged coral but which later I discovered were made of white clay. They had bells on their ankles and several lengths of multi-coloured cloth wound around their waists to which, in the rear, a horse's tail was attached. They strutted in front of us much as the wrestlers had done at Buram. But in Masakin Tiwal the wrestling was more organized. The spectators stood well back from the fighting ground, forming a semicircle behind us, and the Mek acted as master of ceremonies.

He called two fighters into the empty semicircle and they stood there, not moving, for a whole minute, until he gave the signal for the contest to begin. They then sprang to the attack with all the ferocity of tigers, hitting out hard with the sticks against unprotected shoulders and thighs. The weapons they fought with were made of a light wood, tough as hickory, and bore a closer resemblance to clubs than to sticks. Their only protection was the small ox-hide shield they used, with great skill, to deflect blows.

The fighting was fierce and the pace unrelenting. Scarcely had one man fallen than another ran to take his place, and the ground was soon strewn with broken clubs. The men fought furiously, exerting all their strength with every blow. After a few minutes of fighting, one man collapsed from a blow to the forehead. With scant consideration he was dragged away and left in the shade of a thorn tree to make his recovery alone. There was no quarter given and none was asked.

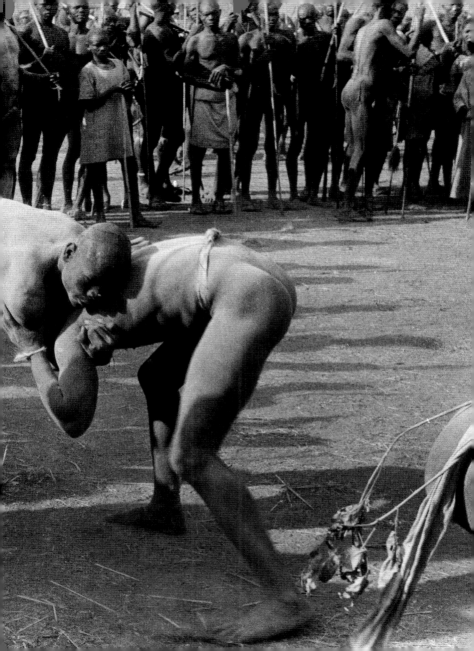

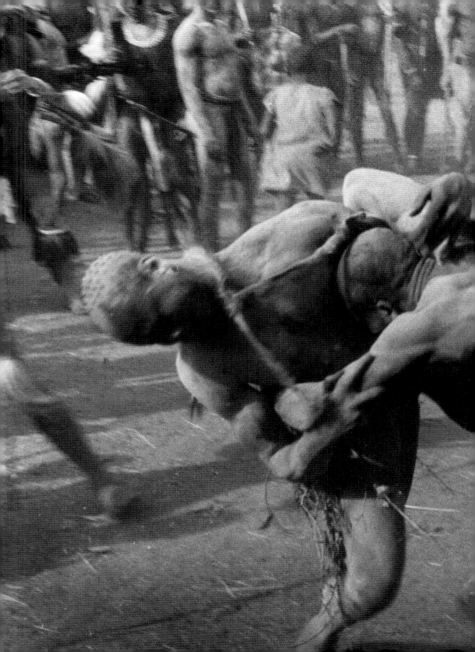

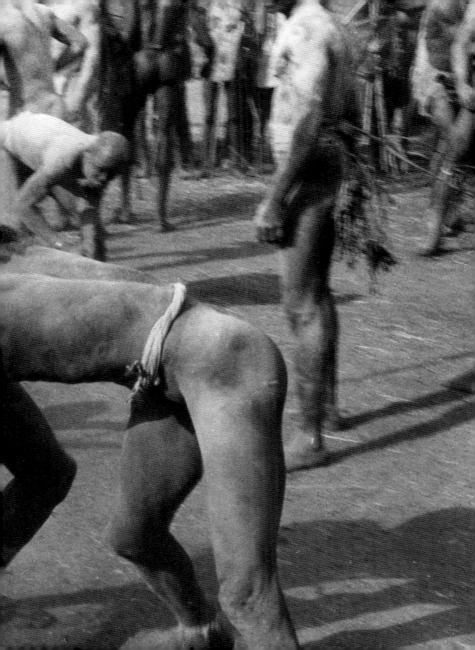

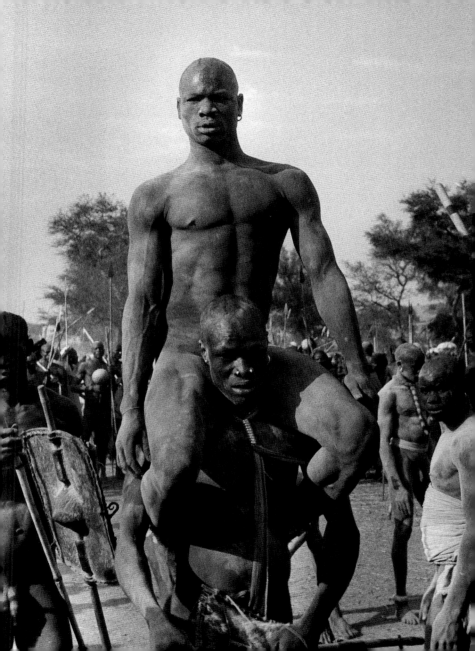

Many encounters,
too many sheep

When the festivities were over we thanked the Mek for his kindness, but we were not permitted to leave until we had accepted our gifts. Ishmael Abdullah, the Sheikh, gave us a chicken. The Mek's present was two fighting clubs and a shield. The winner of the competition gave us 14 eggs. Then we clicked fingers with everyone and were given permission to leave. But six of the fighters chosen by the Mek escorted us to our Jeep while one of the girls followed carrying a gourd filled with sweetened water to refresh us along the way. We clicked fingers all around and drove back to our camp at Reika.

When we got back to the camp, to our surprise, we saw the kitchen boy and the driver busy cutting up meat. The place looked like a slaughterhouse. As well as the sheep which had been a present to us from the Mek of Masakin Qsar and which was already dismembered, a local Arab trader, not to be outdone by the Mek, had also presented us with a sheep. And a third was the gift of a Sheikh who, passing through, had apologized for not stopping since he had still 125 miles to travel before getting home to his own lands. Our boys, delighted with this over-abundance of food, had wasted no time killing the two extra sheep before we got back, since they were afraid that I would regard the double sacrifice as excessive and set one or other of the animals free. But so much meat in such a hot climate created a problem. It would have been impolite to give back a present and even more churlish to throw it away. So I told the boys to select the best

pieces for us and to keep enough meat for themselves to eat that day. Then I called the *Mamour* of Reika, the under-chief, and explained to him that since there were only two of us and our needs were limited, it would be a pleasure for me to see the surplus meat distributed among the poor of the village. Face was thus saved on both sides.

That same night, the Mek of Masakin Qsar came back to find out how we were getting on, and, after enjoying some tea followed by some coffee flavoured with cardamom seeds, he talked to us about the place and his people. I asked him how it had come about that Nubas and Arabs could live together on such good terms after centuries of having been the worst of enemies.

'You are talking about the time that is past,' he said, 'a time that is now forgotten, when the Arabs were the *mazlumeen*, the oppressors. Those days are over. They ended with the Mahdi and, if we were in the wrong, the Nubas no longer harbour any resentment about past events.' He maintained that the Nubas were peace-loving people, strangers to warfare. The nomadic Arabs of Baqqara (the name derives from the Arab word meaning cow) who live in the region own herds of cattle and move from one place to another in the land of the jebels, according to the season. During hot weather, when a great many of the wells are dry, the Baqqara lead their flocks to the rich pastures of the Bahr el Ghazal; then, after the rains have started, they come back to the plains

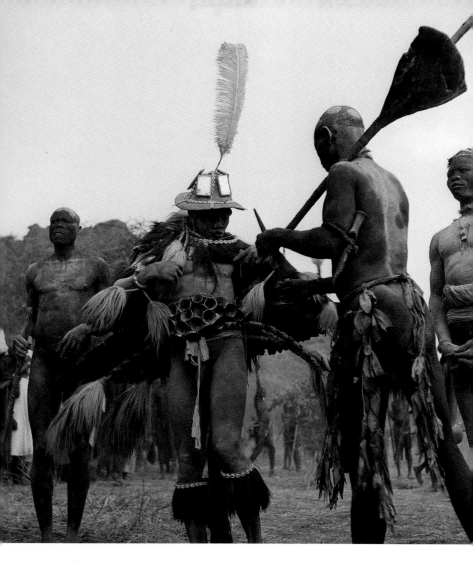

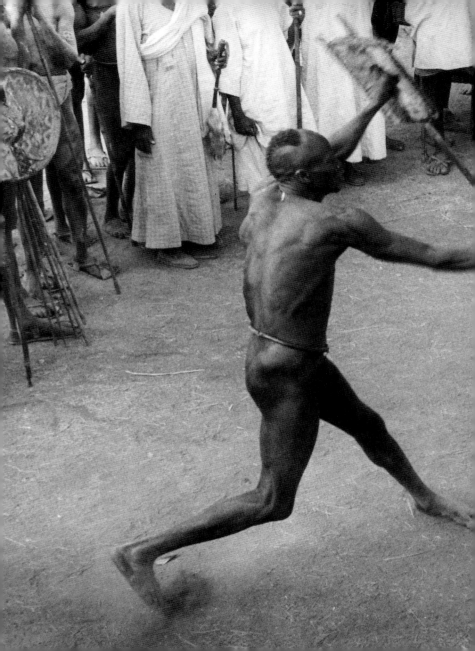

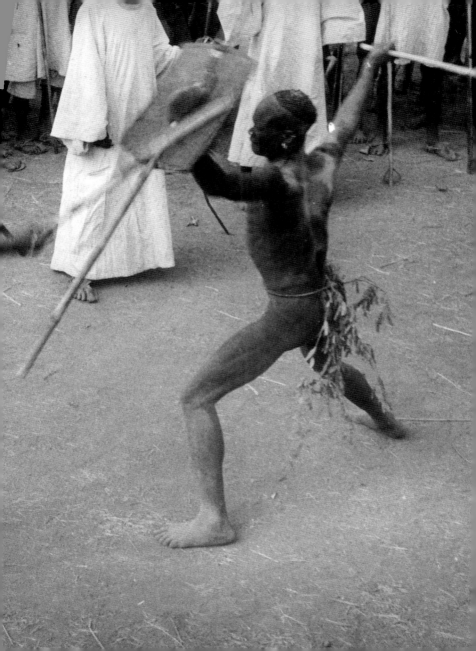

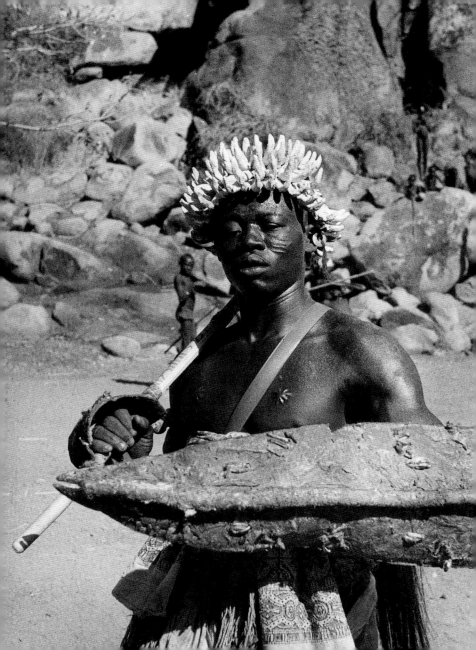

which extend between the jebels. Unlike the Arabs, the Mek explained, the Nubas own no cattle. They are cultivators, living off the earth. And they very rarely travel any distance from their own jebel.

As we listened to him we felt a hankering to see something of the life of the people who share these lands with the Nubas. We asked the Mek if there was any chance of paying them a visit.

'Yes,' he said, 'by the grace of Allah. If you go towards the east you'll meet them.'

Pensively, he lifted his tiny bowl and noisily sucked in a few drops between his lips. Then he took his cigarette, which was now down to the last fraction of an inch, and blew a smoke circle into the darkness. Several minutes went by before he spoke again. 'You've seen the Korongos' wrestling contests,' he said 'and the Masakin Tiwal's stick fighting. But you have yet to see the greatest fighting of all, the bracelet fights.' Trying to hide our interest, for fear of seeming indelicate, we asked in which region these took place.

'If you go towards the east, you will see the Aulad Hemeid, a tribe of Baqqara. And if you go even further east, inshallah, you will reach the groups of jebels which are called the Kau-Nyaro and the Fungor. In that part of the world, the Nubas fight with bracelets.' His penetrating eyes were staring into mine as he added, 'The Sheikh who passed through the other day and left you a sheep was the Sheikh of Kau-Nyaro, Abdul Rahim ibn

Radi, the son of Sheikh Radi Kimbal. In the course of conversation he mentioned that if ever you were to visit Kau-Nyaro he would be honoured to receive you as his guests.'

As we could see, the invitation was perfectly clear. But in the Arabic manner, it had taken two hours of the night and countless bowls of coffee for it to be passed on.

The following morning we left Reika and drove on in the direction of the rising sun to the isolated jebels of the Kau-Nyaro and the Fungor to see the bracelet fighting of the wildest of all the Nuba tribes.

Once again we were following what was more a track than a road, and between six and nine miles an hour was a good average. We had to make our way around deep holes, crevasses formed by water during the heavy rainfall, which were now as dried out as the desert. There were long stretches of soft sand in which our vehicles got stuck up to the axles and we had to set about winching them up. There were craggy rocks and flat rocks, and every kind of obstacle you can imagine, with the exception of rivers, for it was the season when this part of the world was scorched by the sun. Whenever we stopped, we could feel a warm dry wind, and we could hear the incessant murmur of the shifting sand.

It was in this landscape that we first met the Aulad Hemeid. They had set up their encampment around a

well still with a little water remaining and we made up our minds to stay there and spend the night among them.

On our approach, it was only the men who came out to meet us; the women and children stayed out of sight. The men were ceremonious and reserved, quite unlike the Nubas, who were open and spontaneous. But their welcome was just as genuine and, knowing how thirsty travellers can get in this part of the world, they brought a cow and milked it before us, into a deep gourd. The gourd was then offered first to me, then to my wife. We put our hands on our hearts in a gesture of thanks, then one after the other we drank the warm frothing liquid. After a few mouthfuls (it was important to avoid seeming greedy), we held out the gourd to the Sheikh. He touched his heart, tasted the milk and then handed it on to the man next to him. Each of them took no more than a mouthful so as to leave enough for us. The gourd did the rounds several times and in this way we quenched our thirst while taking due care to respect protocol. When the gourd was empty and thrown away, they offered us a shelter for the night in a hut built of reeds, and, in our state of fatigue, we were extremely grateful not to have to pitch our tent and set up camp.

The contrast between the Aulad Hemeid and the Nubas was immediately obvious. Here, only the young children went naked. The men wore voluminous garments which fell right down to the ankles. The women were enveloped in yards and yards of cloth one

end of which they would wind about the head in the manner of an Indian sari. In the presence of strangers, the women covered their faces. Only their eyes were visible. Some of the young girls were more brazen and flashed us broad smiles.

Their houses too were quite different. The Nubas, who only rarely leave their jebel, built permanent huts using dried mud and occasionally stones. Even among them significant differences in dwelling structures mark the various tribes. Those of the Masakin Tiwal, for instance, are most fascinating. Each family lives in a group of five round huts, arranged in a circle around a central courtyard covered with a thatched roof. Each hut has a distinct function: the sleeping quarters, the brewery, the granary, the kitchen and the storehouse. The entrance into the covered courtyard is through a round hole in the wall of each hut, scarcely big enough for someone to pass through it.

The Aulad Hemeid, on the other hand, are nomads and their dwellings, by extension, are less complex. They are built out of large reeds dried in the sun, that can be gathered everywhere during the dry season. Matting made from grasses is spread out across the roofs to act as extra protection against the sun.

There is more than one difference in the diet of these two races. The Aulad Hemeid live off the dairy products of their herds: milk, both fresh and curdled, cheese and fats, while the Nubas work the land and their staple food

is a mash of sorghum, a variety of millet, as well as vegetables. They eat meat, either mutton or kid, only on special occasions.

But the greatest distinction between them is religious. The Aulad Hemeid are Muslim Arabs and followers of the prophet Muhammad, while the Nubas are pagans for the most part. The Nubas are good-natured, kindly and honest, so perhaps they have no need for a religion to make them better people. Their way of life struck us as exceptionally free and uninhibited. There is, by way of example, nothing to bind a couple together and guarantee their happiness beyond the spoken word and mutual agreement. If a man has strong feelings for a woman and if she reciprocates, they live together in a hut of their own and are accepted by all as husband and wife. If the woman has children immediately, the arrangement is regarded as even more advantageous, as help is always needed in the house, to fetch water and to work in the fields. If the mutual affection begins to fade, the couple separate and the whole thing is forgotten. But this seldom happens. One feature of the Nubas' open-heartedness is the enduring and unswerving nature of their feelings.

That night the Aulad Hemeid performed their traditional dance of welcome in our honour. In the moonlight, chairs were put out for us in front of our hut and

two or three hundred people gathered together. They were all in good spirits but there was neither beer to be drunk nor the barbarous thundering of drums to be heard. The festivities of the Aulad Hemeid were well controlled. Musicians assembled in front of the audience carrying cymbals, reed flutes, and small drums which they beat with the tips of their fingers. The band played to a very fast tempo.

The dancers were all young girls, those of the tribe who were not yet married. Lined up facing us in a row, they stood there reeling rather than dancing. With their arms held stiff by their sides, their heads thrown back towards the moonlight, and their eyes closed, they shook their bodies in time to the music and made their breasts quiver. One after the other they lunged forward, and, bending towards me, each one of them brought her face close to mine, rolled her head violently from side to side, and whipped my cheeks with her long black tresses. Each time one girl came forward, the others would trill those same high trills we had first heard in the jebels of Korongo.

When this part of the show was over, everyone joined in and mingled in the dance. We made our excuses and returned inside our hut, which had in the meantime been prepared for us.

I slept soundly until just after sunrise when I awoke

with the feeling that something was wrong. I was horrified to see a man kneeling by the bed where my wife was sleeping. He had his back to me and I tried as quietly as I could to put my hands on some object with which I could strike him. My boy was in the habit of putting a javelin next to my bed every evening in case of emergencies. I thought that if I could reach it without the man hearing me, I would be able to put up a good fight. Wrapped in a blanket, lying on a camp bed, is not the best position for either attack or self-defence. So I sat up quietly only to hear him speak. In a low voice, in Arabic, he repeated the same words over and over, almost inaudibly, 'Wake up,' he was saying, 'the sun is rising.'

Then, shifting forward a little, I saw he was holding a gourd filled with fresh milk cupped in his hands and I felt ashamed for having regarded his broad back merely as a target for my javelin.

I lay down again and he heard me stir. Turning, he offered me some of the milk with these words, 'By the grace of God, a new day is with us.'

And so I drank, as did my wife, upon awakening.

Our thanks for the accommodation, the entertainment and the hospitality provided by the Aulad Hemeid were sincere. They and the Nubas had three qualities in common. Three rare qualities: generosity, hospitality and kindness.

A new day spent on the same deplorable roadways

took us to the jebels of Kau-Nyaro. We arrived at night. The moon was full and bright like daytime and the big baobab trees, weirdly surrealistic, stretched their gnarled fingers in silhouette against the sky. It was hot and there was the sweet smell of frangipani in the air. We camped by the village of Kau which, unlike most Nuba villages, was compact and built at the foot of the jebels. Sheikh Abdul Rahim ibn Radi of the village met us upon our arrival and showed us a suitable camping ground beneath the spreading branches of a Smyrna fig tree. He gave us a young goat as gift.

Tall, brawny, naked Nubas came with further gifts. A chicken, a handful of eggs, a gourd filled with goat's milk, or a little honey, and they busied themselves clearing up the branches and foliage that had fallen on the ground about our hut to ensure all was kept clean. Like the Nubas of Korongo, they were handsome men and of the same height, yet less heavy and perhaps more agile. On their more slender frames the extraordinary muscular development was even more evident. The colour of their skin was a shade lighter. All of them carried javelins with polished blades and wore little amulets of animal hide tied around their necks or massive biceps.

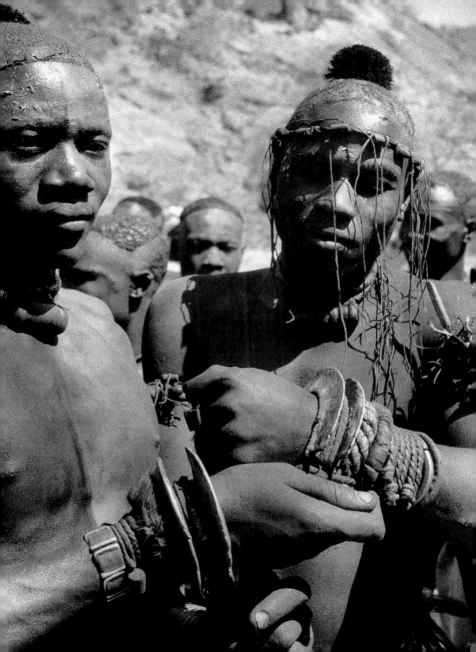

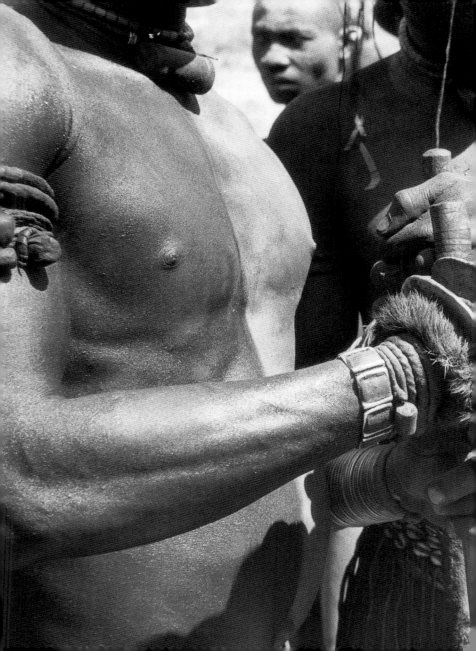

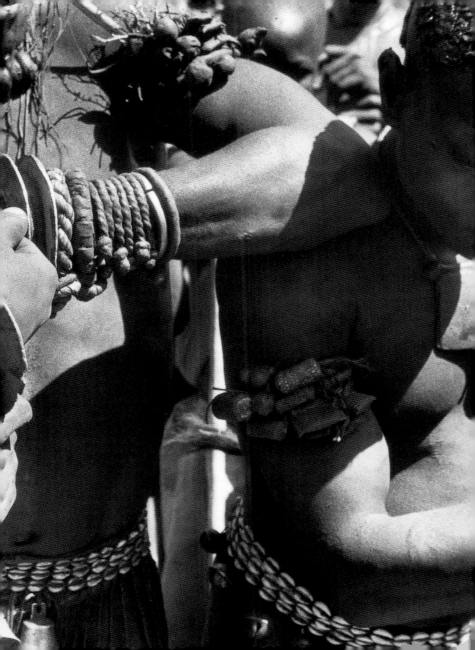

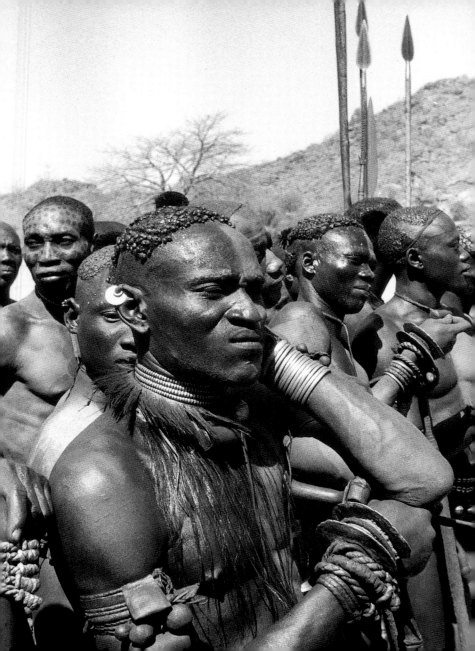

Details of a bloody
combat

We had tea with Abdul Rahim who told us that a bracelet fighting contest was to be held immediately after our arrival. The contest would match the men of Kau-Nyaro against the men of Fungor, the neighbouring jebel. Now that we had arrived, he would at once send runners, through the night, to summon the fighters in Kau. The battle would take place the following day.

Since it had been a long day, we retired to our hut early. As we approached it, two naked giants emerged from the shadows either side of the door. When we passed between them they made no movement, and just went on standing there, leaning on their javelins. They were our guards. There were two more inside the hut, and they remained in a squatting position on the ground. From our beds we saw that the two guards effectively blocked the entrance. We could see the moonlight reflected on their javelins.

The following day we were awakened by three giant Nubas who sat themselves down by the entrance to our hut and beat out a soft, mellow rhythm with their fingers on drums which they held between their knees. Their naked bodies were painted in harlequin design with coloured clay mixed with sim-sim oil.

We breakfasted to the beat of their drums and, by the time our meal was over, six young girls had joined the drummers. They too wore no clothing but had painted themselves so liberally with different coloured clays that some were red, some yellow, and the oil they used

dripped from their long plaits of hair. They danced solemnly and with a grace that we had not seen in any other part of Africa. The hand movements they used were more oriental than African. They carried rawhide whips which, now and again, they held taut between outstretched arms whilst they postured with feet set firmly apart.

As they danced the drums beat louder and faster into a more frenzied rhythm. The fighters of the tribe, in their black and yellow warpaint, pranced up in twos and threes to give their wild challenging cry before the drums.

Finally, the Sheikh arrived and told us that during the night he had summoned the fighters from the neighbouring villages of Nyaro and Fungor, and they were ready now to challenge the fighters of Kau. We followed him to a small clearing beyond the village which was ringed by tall rocks and baobab trees. The men from the different villages sat in groups apart from each other and we soon found that the fights were to be more than just a demonstration for our benefit. The village's prowess was at stake.

I examined the bracelets with which they fought and I have seldom seen more lethal weapons. They were heavy, made of brass – each about four pounds in weight – and they had double jagged-edged flanges, two inches

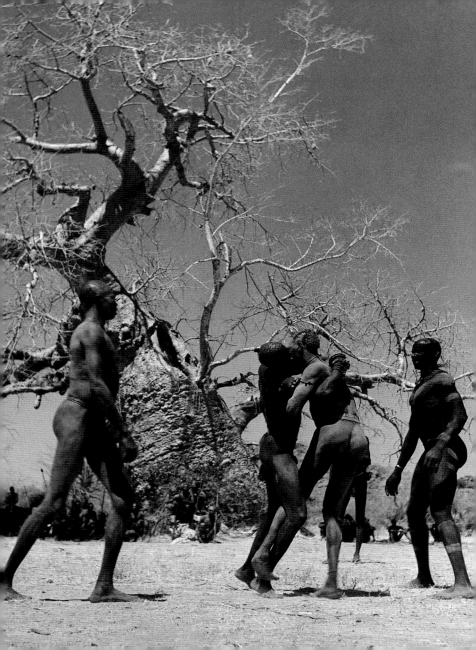

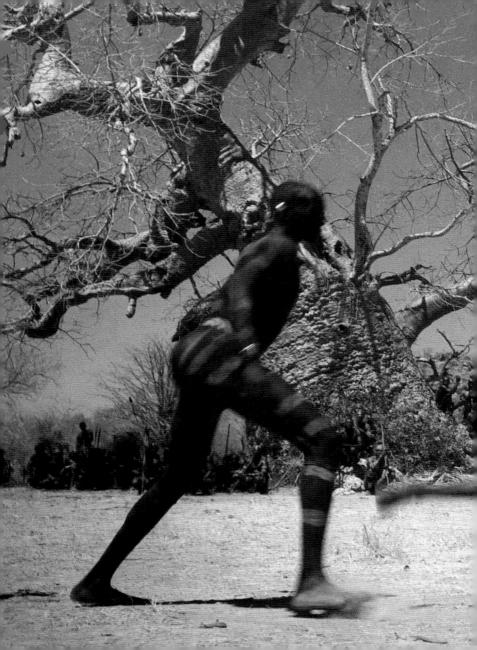

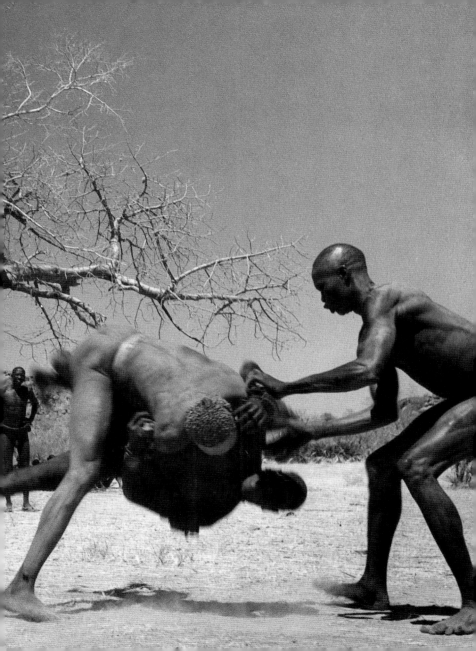

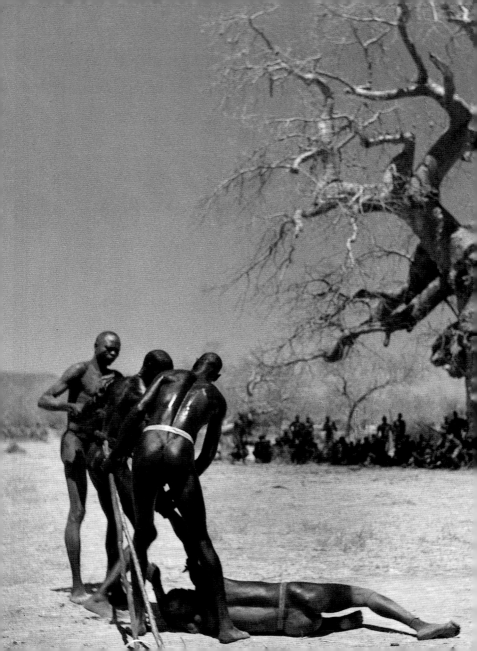

high, capable of breaking open the skull of an unwary opponent as one might crack the top from a boiled egg. In spite of the obvious danger of receiving a fatal blow, the fighters carried no shields nor did they have any form of protection for their naked bodies. In fact, besides the single bracelet strapped on one wrist, they wore nothing but a small brass bell which dangled from a leather thong around their waists.

When we were seated with the Sheikh of Kau beneath a baobab, the fighters entered the arena running in pairs. They came with a loping gait so the bells they wore around them jingled as they ran. Then the fighting began. A man from Kau was selected by the Sheikh and he was challenged by another from Fungor. Each fighter had his second with him in the arena. He was armed with a staff with which to break up the fight and prevent a killing should one of the combatants fall.

The atmosphere was tense with excitement and we were being joined by an ever larger crowd, as the men brandished their javelins and their curved knives. There were old men waving their weapons about and shouting. The women made their ululating cries non-stop. The fighters in their black and yellow warpaint strutted haughtily in groups of three or four, waving their javelins above our heads. Then they stuck their thumbs right into their mouths, and their whole bodies seemed to writhe about as they let out their war cry, the most terrifying sound I have ever heard uttered. Around us there was

total pandemonium. All that we ourselves had to do was get on with drinking our coffee and wait for the events to unfold.

They did so with the arrival of Sheikh Abdul Rahim. Forcing his way through the crowd, his white robes soiled from brushing against oily bodies, he raised his hand. There was a hush. He then announced to his tribe that the engagement between the Kau-Nyaro and the Fungor was about to begin. With a great shout raised from hundreds of throats, the crowd turned round and rushed in the direction of the ground where the contest would take place. We followed at a calmer pace with Abdul Rahim.

The fighters first fenced with long staves, dancing round each other nimbly, feinting and parrying and thrusting at each other's head with savage blows. Then, as though at a given signal, the staves were hurled aside and they went for each other with bracelets raised. They fought wildly, savagely, crashing the heavy bracelets down on unprotected heads so we could hear the dull crunch of heavy brass biting into bone. Blood poured from their heads and necks where the bracelets cut deep. But they fought on, eyes blazing and fists flailing madly snarling as they fought. After a particularly savage blow, one man disentangled himself from his opponent's clinch with a four-inch gash at the base of his skull. Blood poured in a glutinous mass over his back and buttocks, down to his ankles, yet he fought on and paid no more

attention to it than a boxer would to a black eye. During another bout one of the fighters had the teeth smashed from his bottom jaw, but it was always the same – the more blood that was spilled the harder they fought. It was only the intervention of the seconds that prevented a killing.

High above the rocks the frenzied shouts of the onlookers broke the silence. Drums began beating. Young girls flung themselves into the fighting arena to dance, taking up their positions in front of the winner, and, with his thumb in his mouth, he once again let out a piercing battle cry. Beside us, the Sheikh rose from his seat and strode quickly down into the fighting ground to re-establish order. Once more silence fell when he lifted his arm. Two more men were picked out. Then another two, and the fighting went on throughout the day.

Finally, late in the evening, Sheikh Nuru of Kau looked at us and smiled, 'Are you enjoying the fighting?' he asked, so benignly that had he suggested his fighters kill each other for our amusement, I would not have been surprised. 'Yes,' I replied, 'and the men of Kau are the greatest fighters of them all.' He asked for my permission to send the men back home to their villages. The day's spectacle had ended.

The dancing girls trooped off home singing together and tripping a few light-hearted steps in the sand as they went. The drummers tucked their drums beneath their arms and walked off towards the jebels. The fighters

trotted home with bounding steps so the bells on their bodies rattled, and those whose heads had been split open rubbed their wounds with dust from the ground to stop the bleeding. They argued and laughed with their companions as they discussed the fights in detail and acted more as though they had been spectators rather than badly battered participants.

One, with a four-inch triangle of scalp hanging loose, came to our hut afterwards and, smiling shyly, gave us a present of three eggs.

That gracious gesture, coming immediately after a demonstration of such primitive savagery, was as impressive to me as the actual fighting had been, and when we came to leave the Nuba jebels with their fierce, untamed, lovable tribesmen, we took with us only memories of a people, primitive it is true, but so much more hospitable, chivalrous and gracious than many of us who live in the 'dark continents' outside Africa.

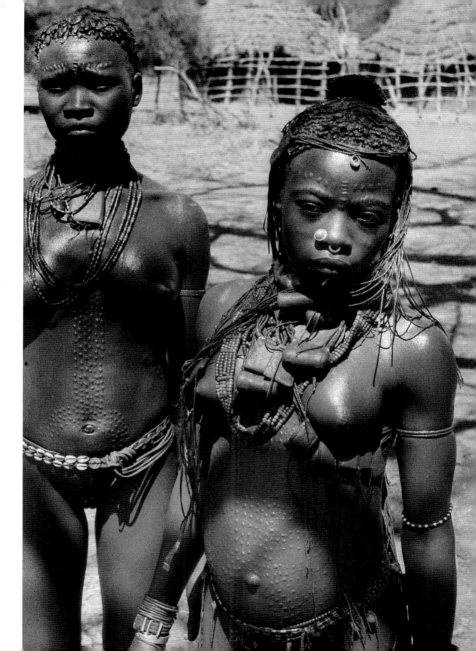

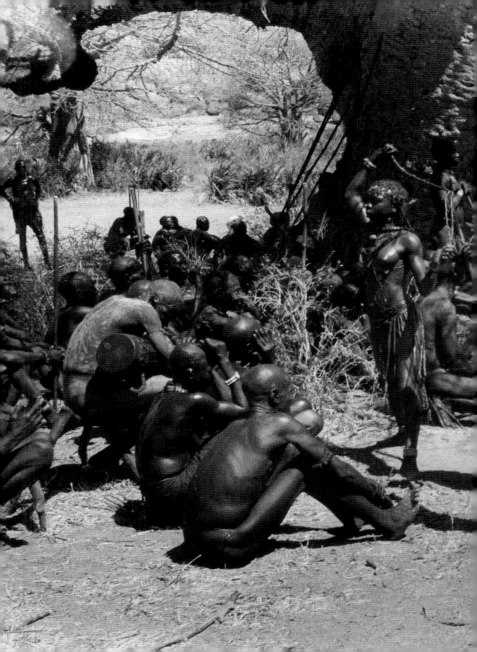

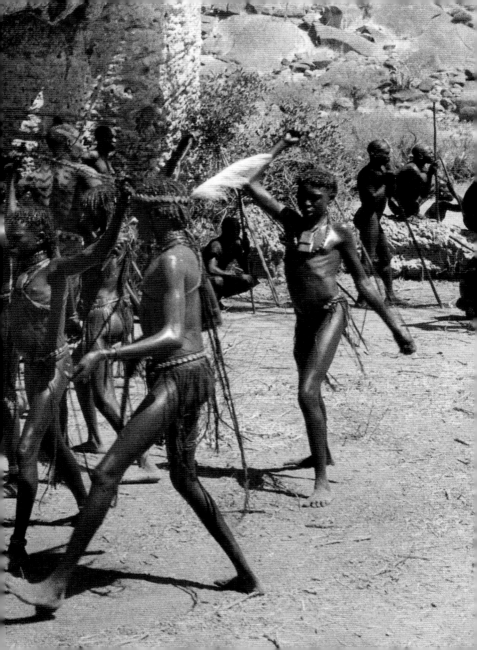

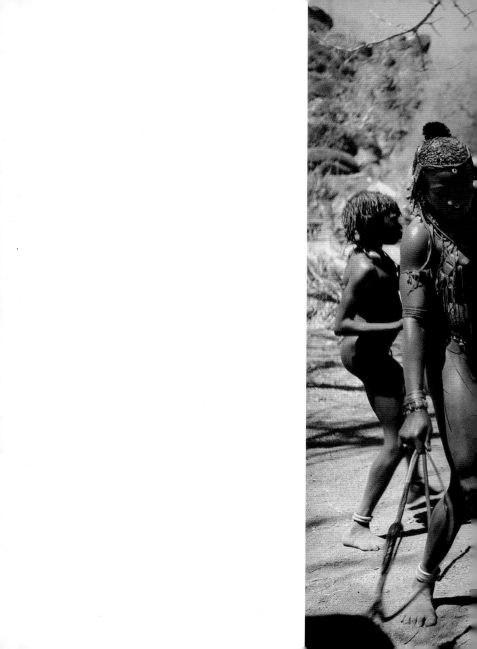

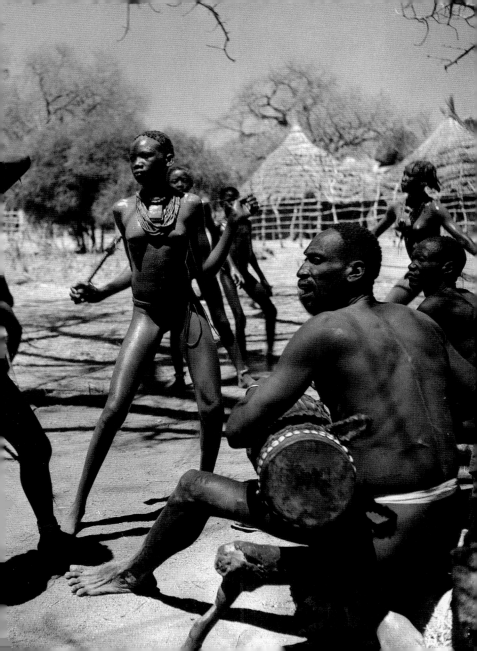

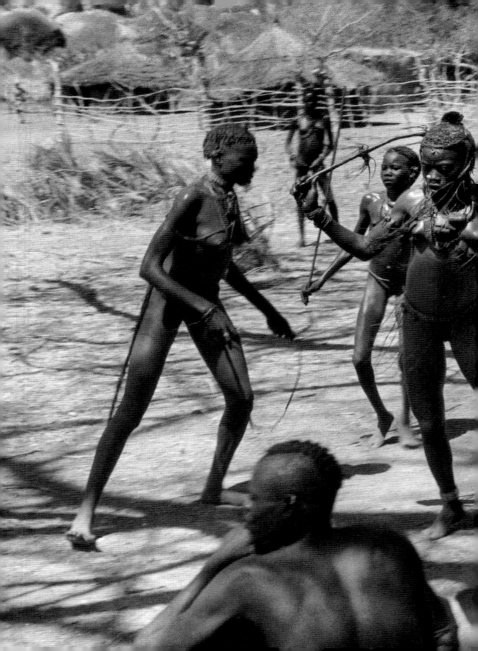

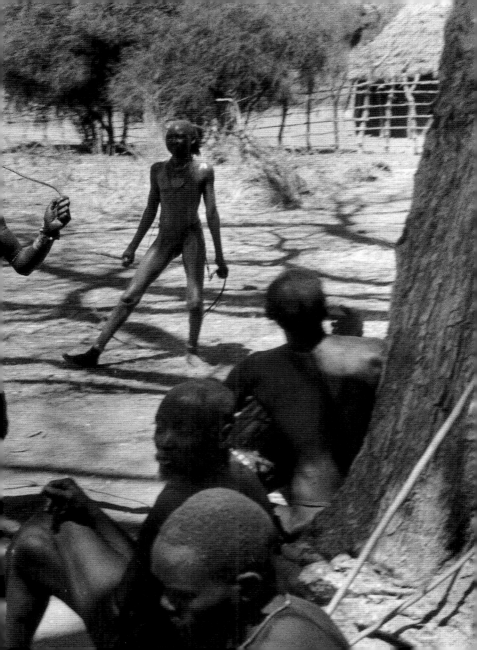

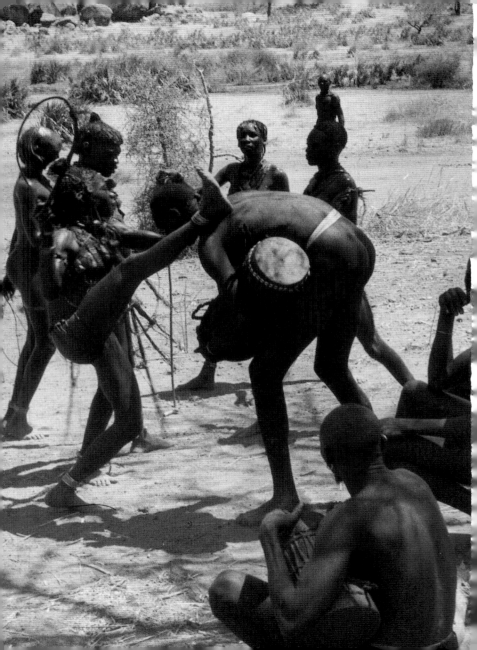

Phaidon Press Limited

Regent's Wharf

All Saints Street

London N1 9PA

First published, in French, by Robert Delpire, éditeur, 1955

This edition, first English language edition © 1999 Phaidon Press Limited

Photographs and original photographer's text © 1955 George Rodger Estate

Introduction by Peter Hamilton

Translations by Liz Heron

ISBN 0 7148 3840 3

A CIP catalogue record for this book is available

from the British Library.

Printed in Hong Kong